T0132402

Do You Need A Hug

Johanna A Ferket

To order additional copies of this book, contact:
Xlibris
844-714-8691
www.Xlibris.com
Orders@Xlibris.com

ISBN: Softcover 978-1-6698-5641-2
 Hardcover 978-1-6698-5642-9
 EBook 978-1-6698-5643-6

Print information available on the last page

Rev. date: 11/17/2022

I watched her; she was so happy, different, and bright like the sun. I had to follow her!

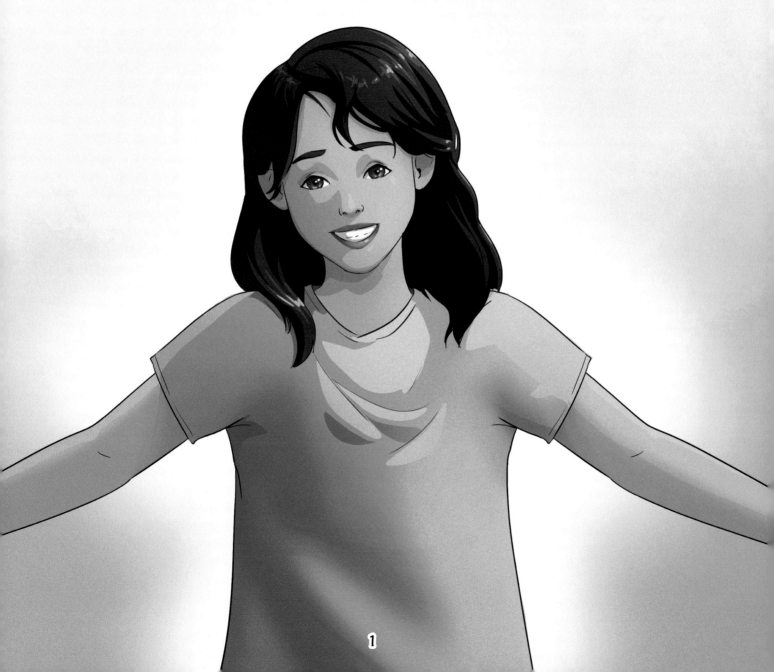

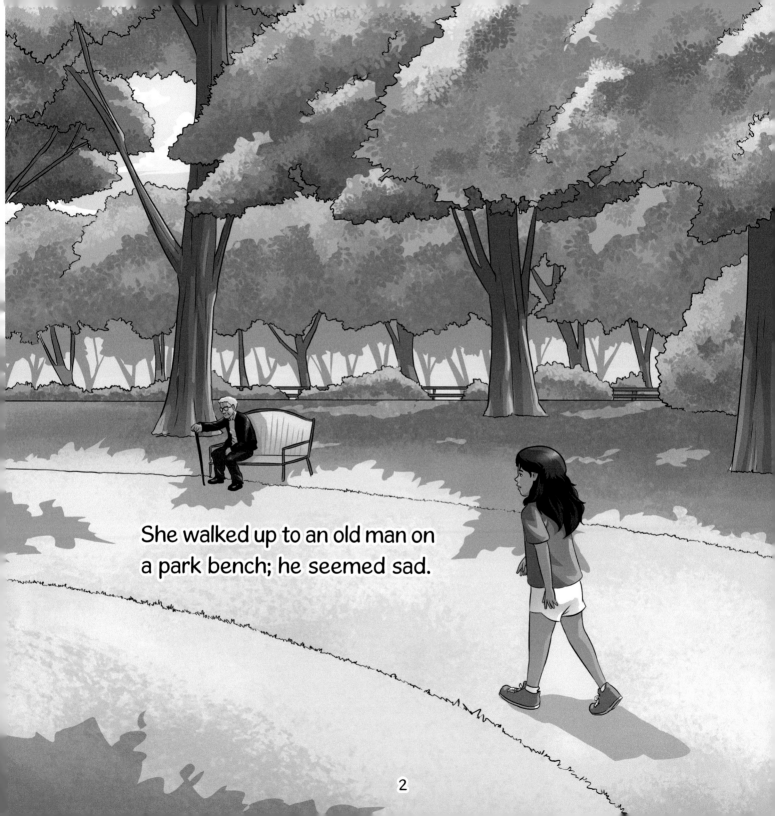

She walked up to an old man on a park bench; he seemed sad.

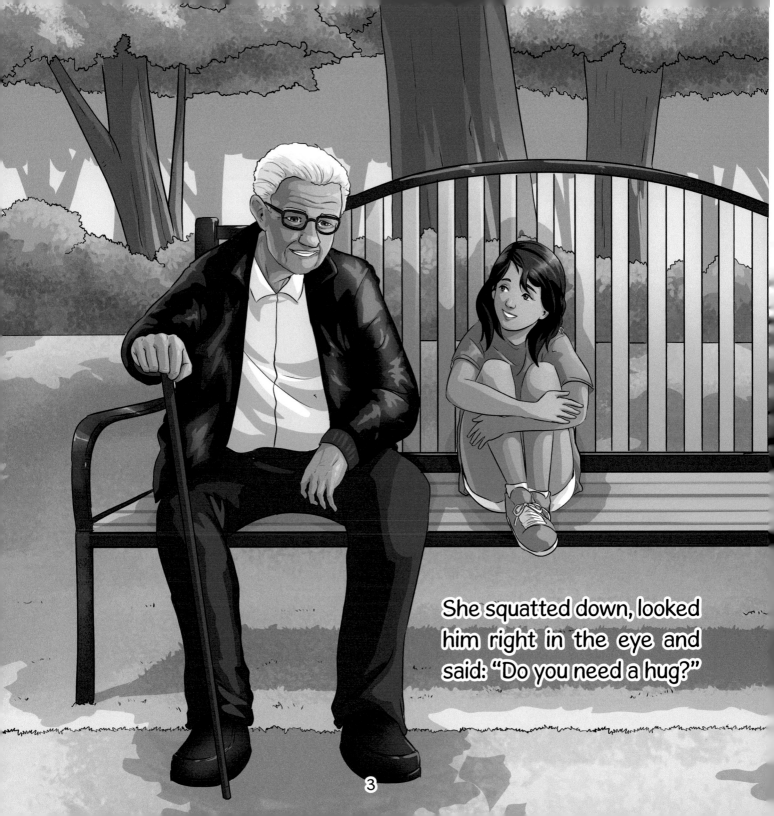

She squatted down, looked him right in the eye and said: "Do you need a hug?"

3

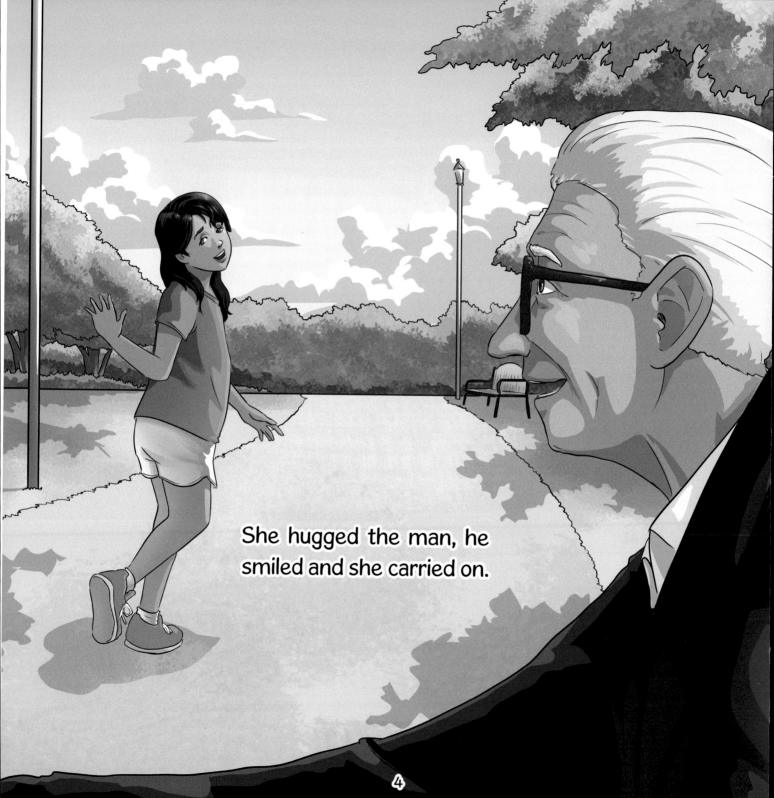

She hugged the man, he smiled and she carried on.

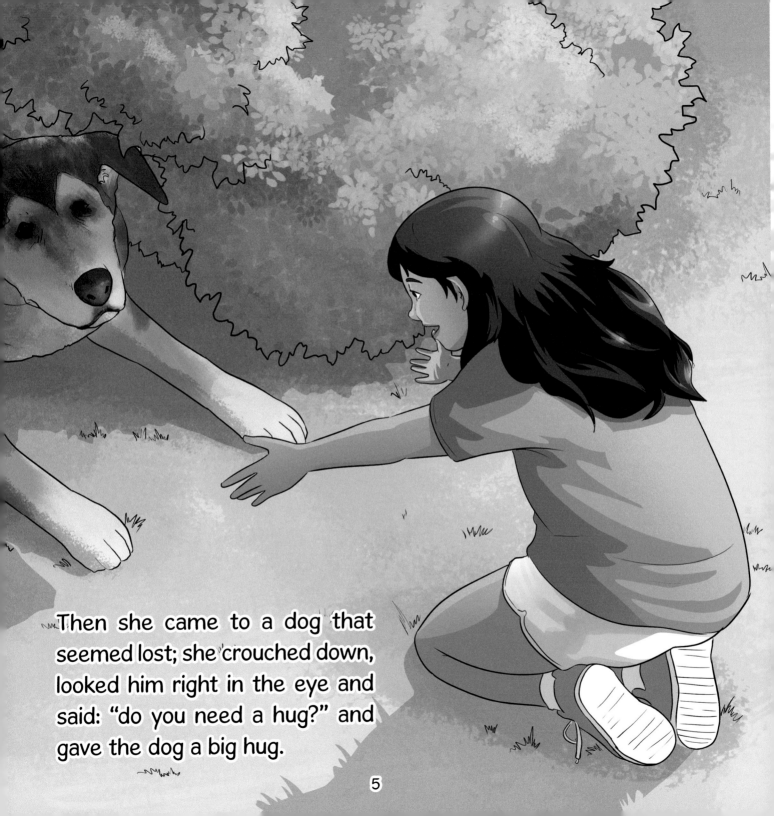

Then she came to a dog that seemed lost; she crouched down, looked him right in the eye and said: "do you need a hug?" and gave the dog a big hug.

5

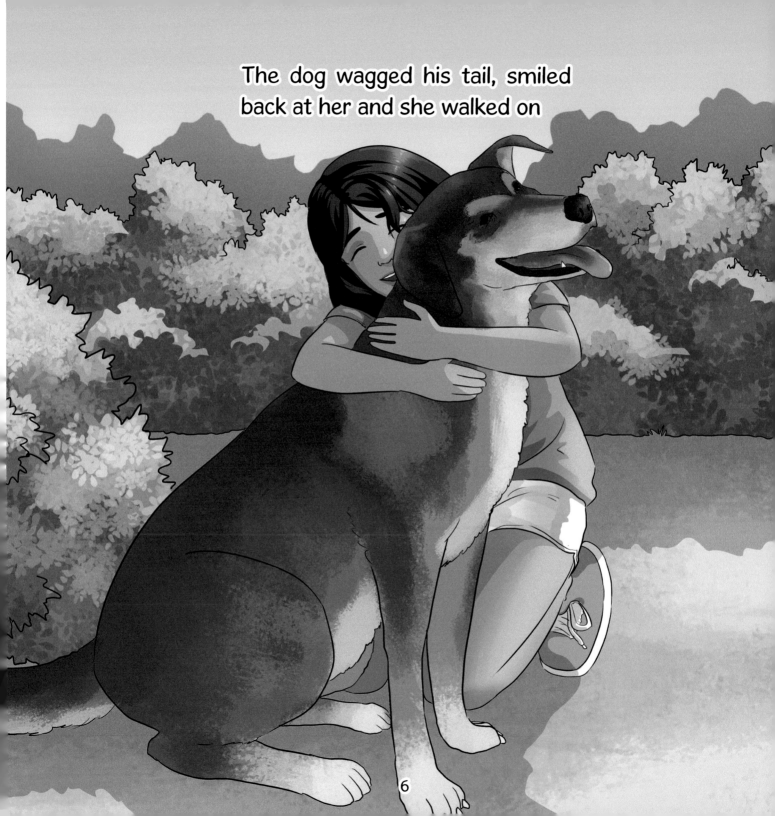

The dog wagged his tail, smiled back at her and she walked on

6

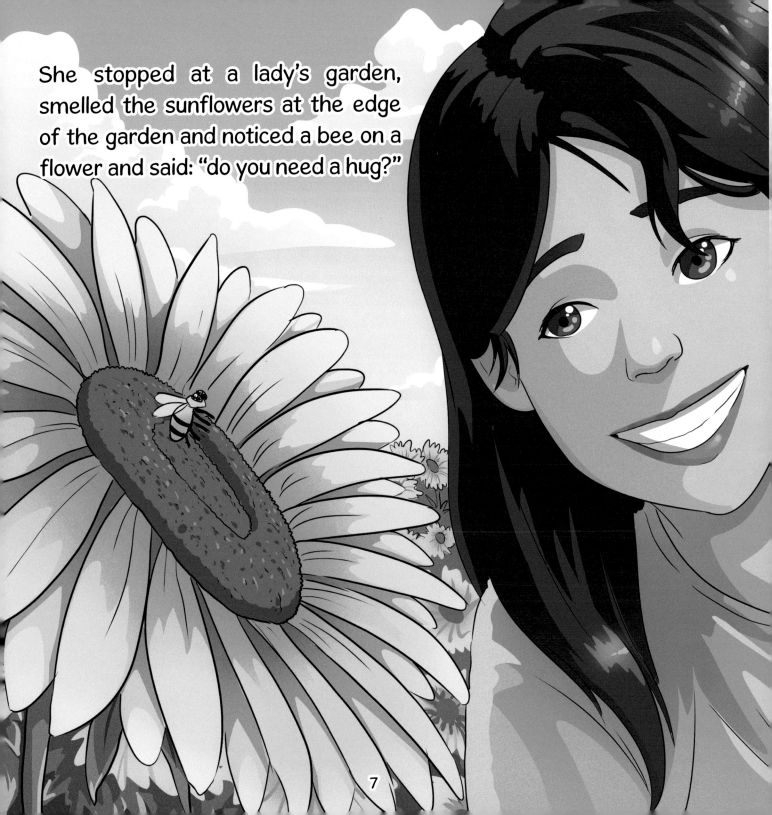

She stopped at a lady's garden, smelled the sunflowers at the edge of the garden and noticed a bee on a flower and said: "do you need a hug?"

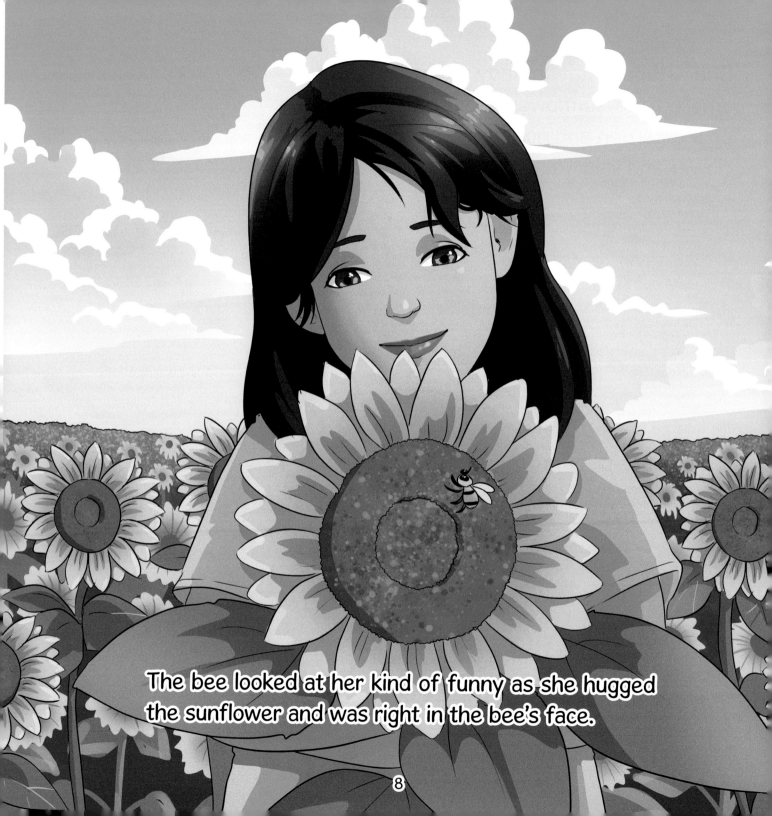

The bee looked at her kind of funny as she hugged the sunflower and was right in the bee's face.

8

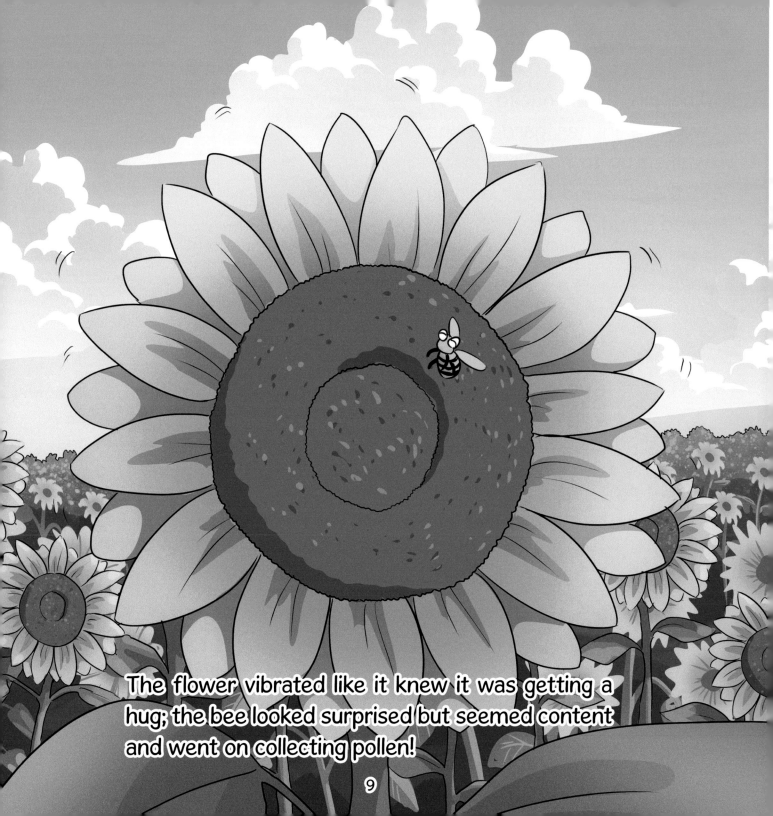

The flower vibrated like it knew it was getting a hug; the bee looked surprised but seemed content and went on collecting pollen!

9

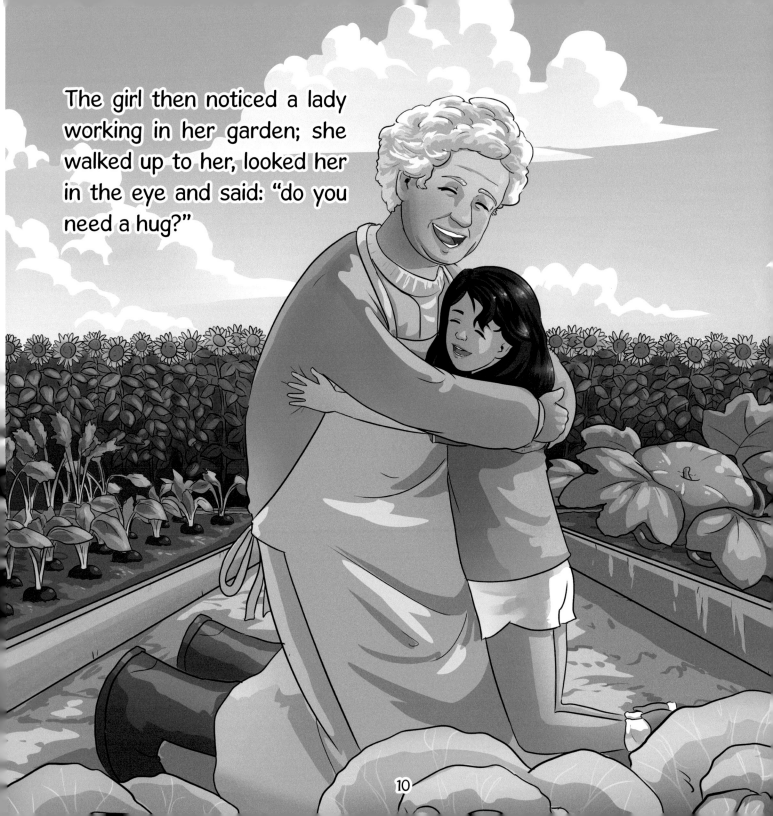

The girl then noticed a lady working in her garden; she walked up to her, looked her in the eye and said: "do you need a hug?"

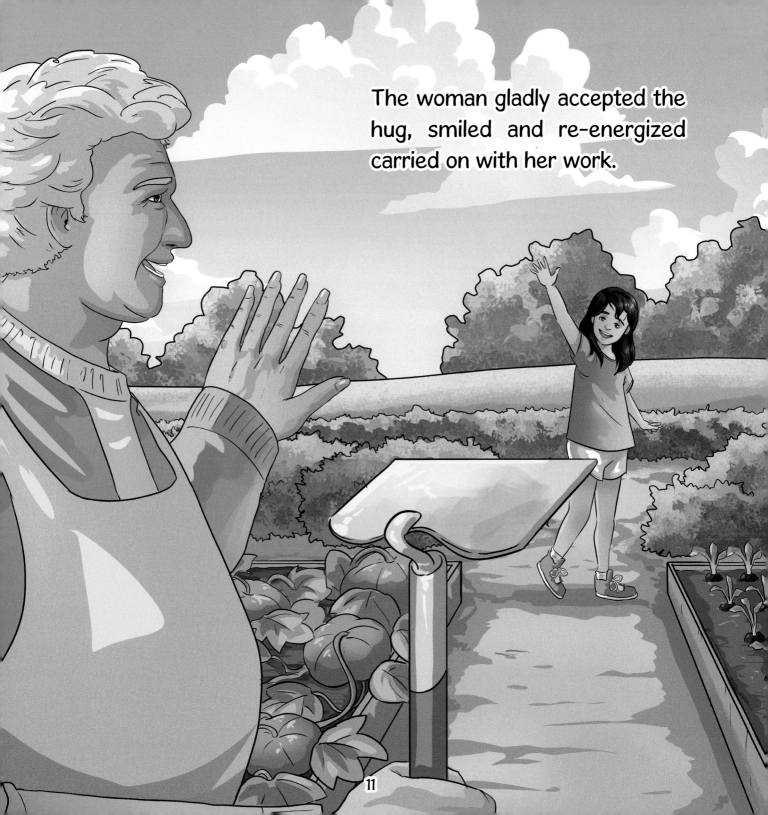

The woman gladly accepted the hug, smiled and re-energized carried on with her work.

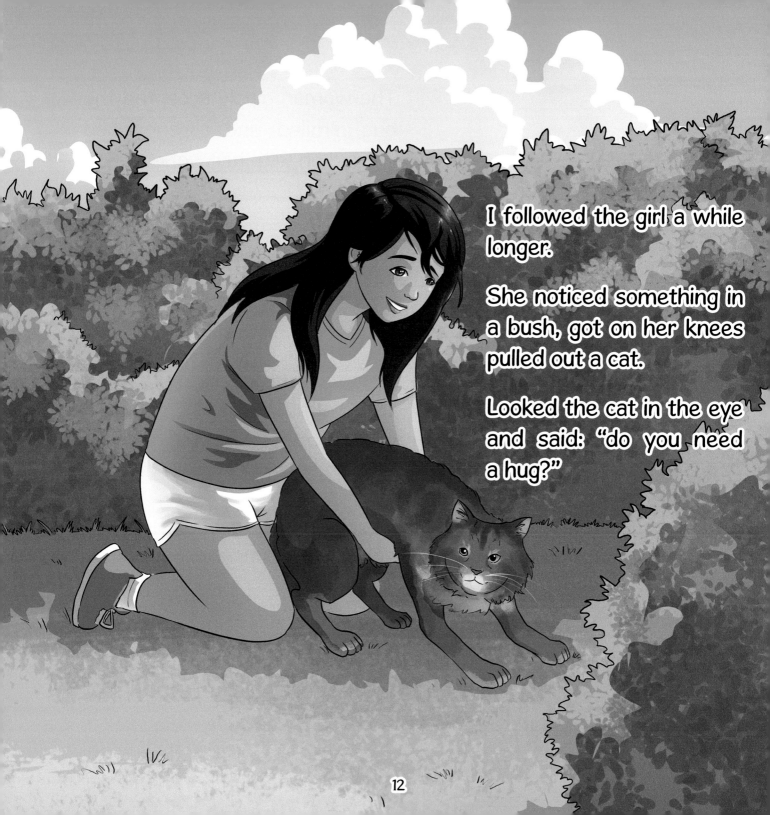

I followed the girl a while longer.

She noticed something in a bush, got on her knees pulled out a cat.

Looked the cat in the eye and said: "do you need a hug?"

The cat purred and rubbed herself against the girl, she laughed and went on her way.

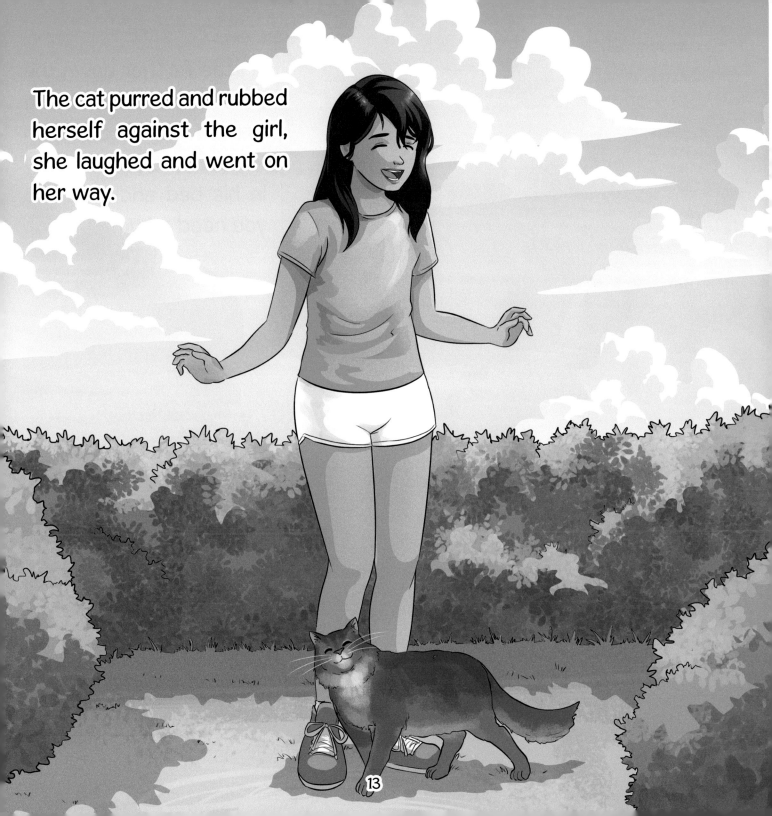

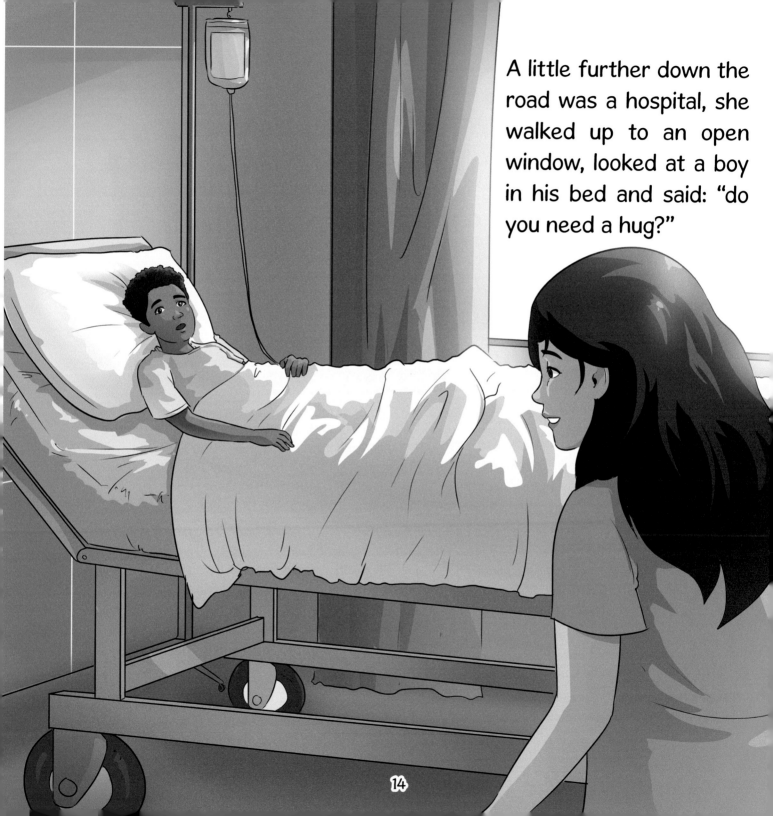

A little further down the road was a hospital, she walked up to an open window, looked at a boy in his bed and said: "do you need a hug?"

14

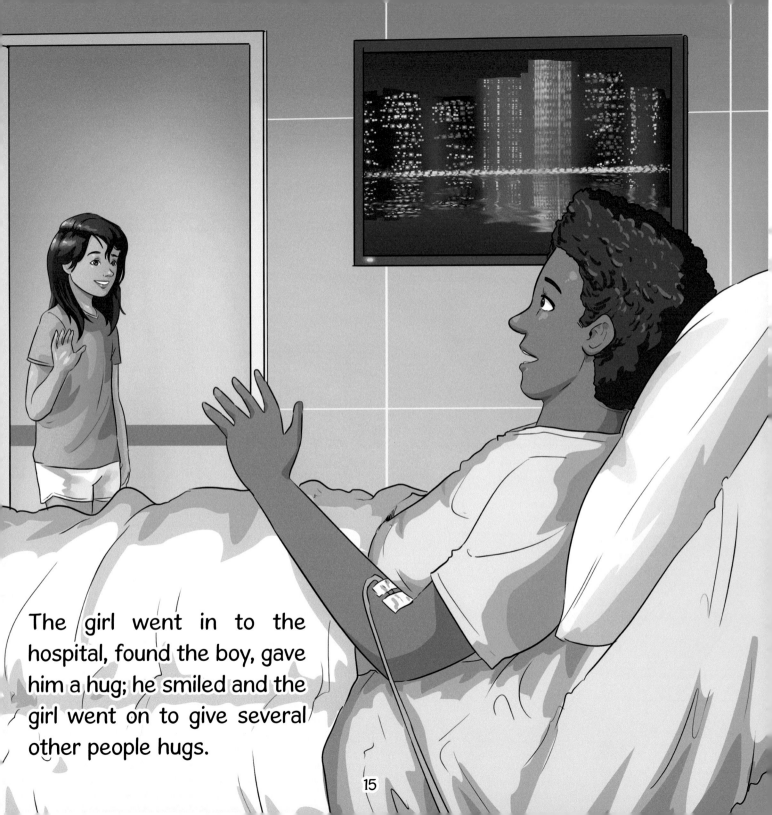

The girl went in to the hospital, found the boy, gave him a hug; he smiled and the girl went on to give several other people hugs.

She changed the hearts of so many people; smiled and went on her way.

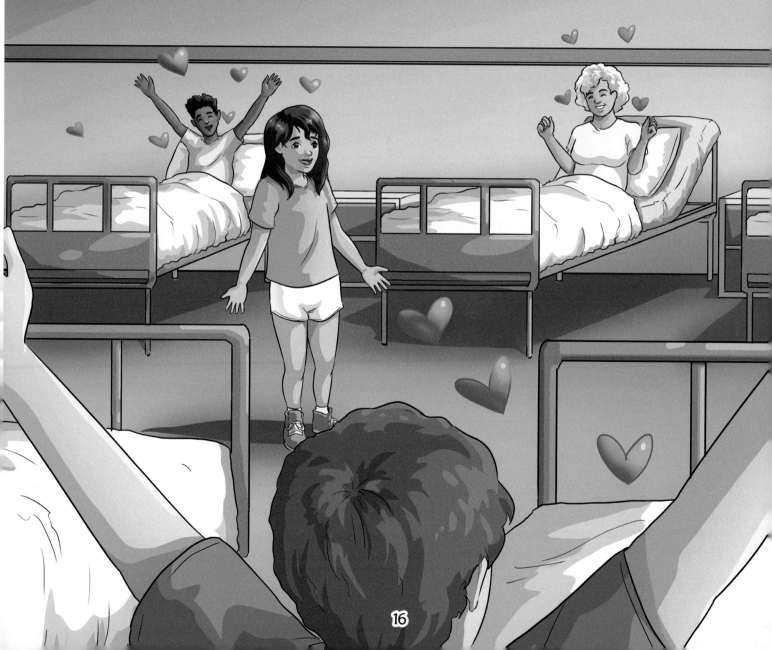

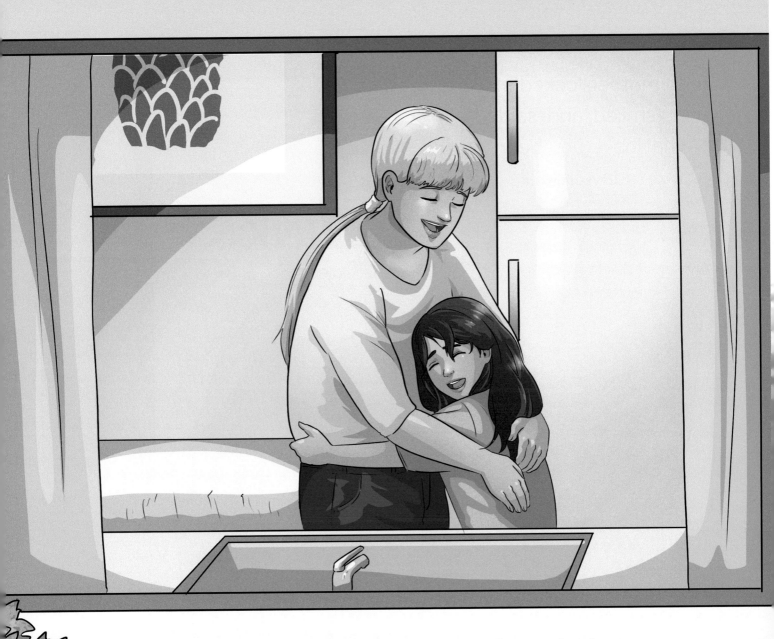

The girl made her way home so I watched
through the window as she looked her mother
in the eye and said: "do you need a hug?"

Her mother looked at her, smiled and said: "what have you been up to today child?"

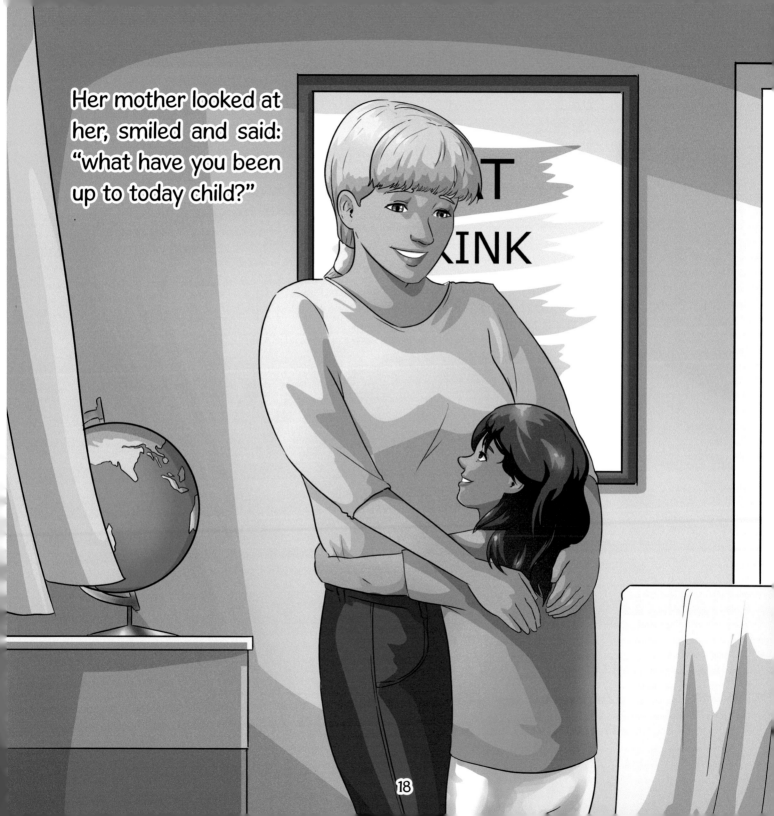

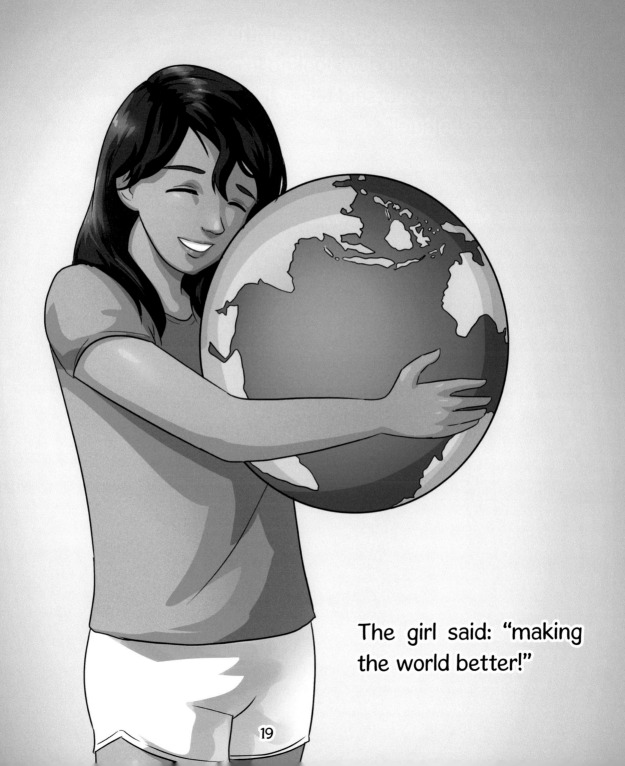

The girl said: "making the world better!"

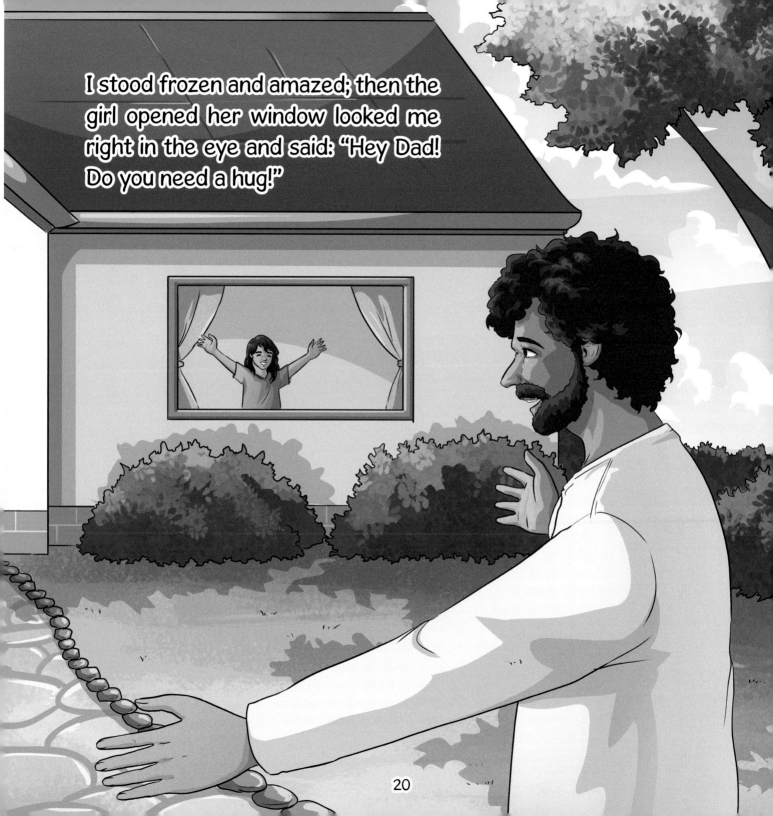

I stood frozen and amazed; then the girl opened her window looked me right in the eye and said: "Hey Dad! Do you need a hug!"

20

Printed in the United States
by Baker & Taylor Publisher Services